MW00327444

Book of Poems

By Talyn Fiore

This book has a piece of me on every page. I poured my heart and soul into the writing, design, and creation.

Every detail was intentional.

The blur of each black circle represents the gender of the poem's muse. It blurs on the left for female and on the right for male.

I believe in the power of numerology and repeating numbers. They encode energetic frequencies into colors.

The number 3 is the guiding force of the book and my favorite number. It stands for creative self-expression. The black pages, fonts, and lines are 60C, 40M, 40Y, 100K, which add to 240, which add to 6. The vertical lines are 3 inches. There is a 6-page sequence that repeats 18 times, which add to 9. The font sizes are 33 and 12, which add to 3. The line spacings are 33, 24, and 18, which add to 6 and 9. All numbers reduce to 3.

This number 8 is known for harmony, empowerment and infinity. ∞ Signifying the balance within us all, the yin and yang, the masculine and feminine, the light and dark. The book is 116 pages, which add to 8. The book is 8x8.

This book taught me so much about myself. My wish for you, reader, is that this book plants a seed of hope in your heart.

Who would have guessed
that after i left
you'd become my muse.
My spark of inspiration.
Even gone
you've cracked open a piece of me
I thought long forgotten.
Like a compass,
you continue to direct my course.
Leading me
deeper and deeper
into myself.

This book is dedicated to P.

Please always know,

Everything happened perfectly.

The end is never truly the end.

Every day a piece of the world

Reminds me of you.

Keeping our love

Alive forever.

Love every chance you get.

Love them the way you loved me.

My god,

All i know is,

Nobody loves the way you do.

If I could dream
of a perfect day
I'd be in a cabin with you
far far away.

Holding hands and
talking deep,
maybe then
you'd be able to sleep.

You would brush my hair.
I would pop your back.
We'd dance for hours
in our tiny shack.

The world is unknown
it scares me so,
but I know with you
I'm never alone.

The dream fades away.
Its absence brings tears.
I wake up surrounded
by my childhood fears.

I walk through the doors.
Instantly it feels like home.
Pieces of you everywhere,
I begin to roam.

No clocks, no windows,
swirls of cigarette smoke.
People coming and going,
everyone going for broke.

Nostalgia begins to
soak through my bones.
Though all I can hear are
the slot machine tones.

'Take your kid to work day'
always brought us here.
The memories rain upon me,
so many I hold dear.

It's nice to feel close to you.
That's something I miss.
I look towards the sky
and blow you a kiss.

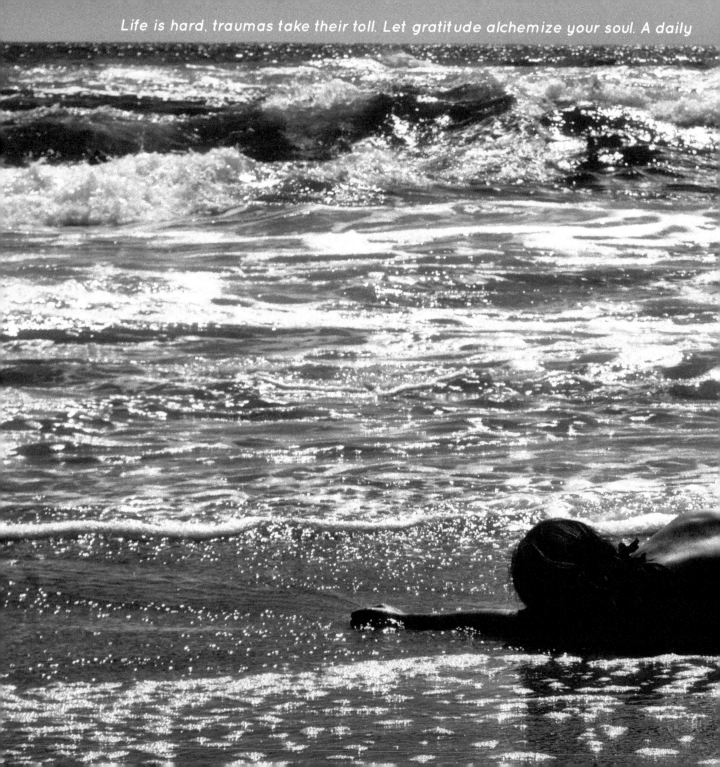

Life is hard, traumas take their toll. Let gratitude alchemize your soul. A daily

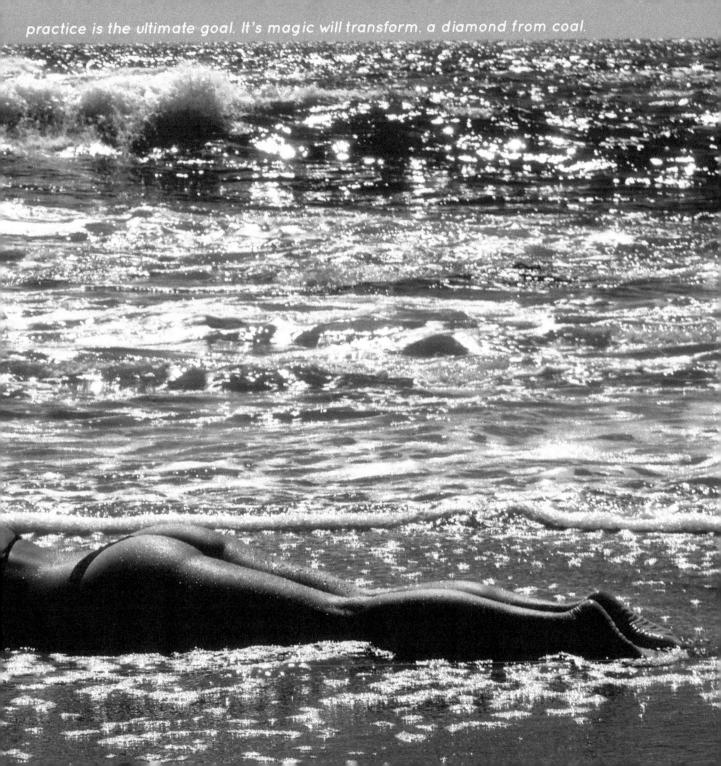

practice is the ultimate goal. It's magic will transform, a diamond from coal.

Rich in belief,

In everything really.

Cunning, creative, charismatic.

Hardworking beyond measure.

A father first.

Ready to give everything,

Die even,

For his family.

I am just like you, dad,

Opportunistic and opinionated.

Ready to believe,

Everything and anything are possible.

Nature is constant,

she never leaves me.

She is the only one.

You said *I love you*
and you meant it,
more than anyone before.

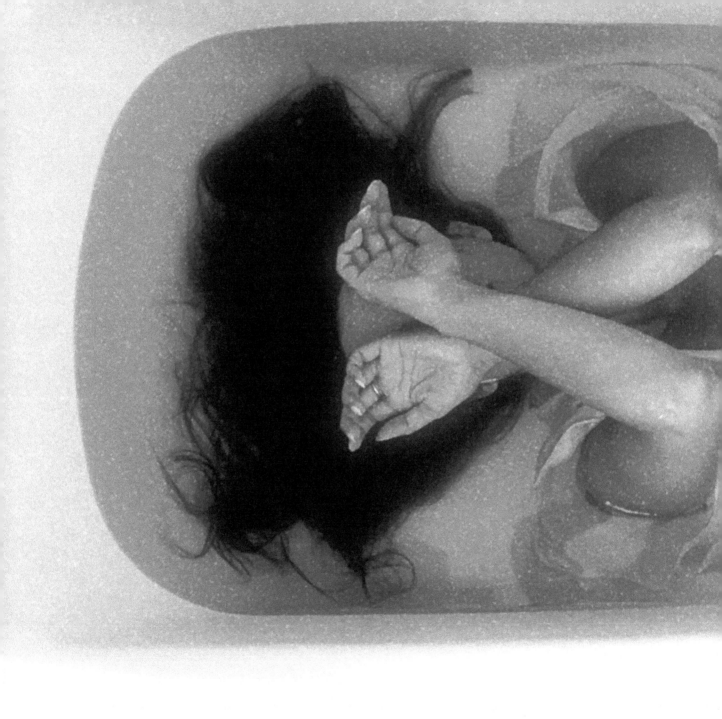

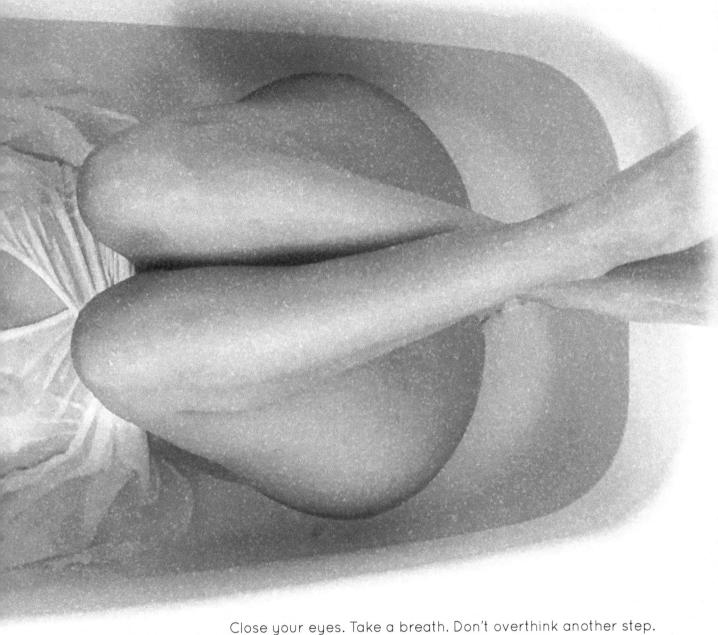

Close your eyes. Take a breath. Don't overthink another step.
Hear the calm. Energetically align. Give your soul a moment to shine.
Anchor in. Feel the breeze. Give your inner child a squeeze.
Be present. Slow down. God is running the show now.
Let go. Take the dive. To be still is to be alive.

The stage, the first place i truly felt like myself.

Heaven on earth, having something just for me.

Enamored, to be the center of attention.

Authentically myself:

Talkative, tenacious, tender.

Realizing the romance in performing,

Entertainment became my calling.

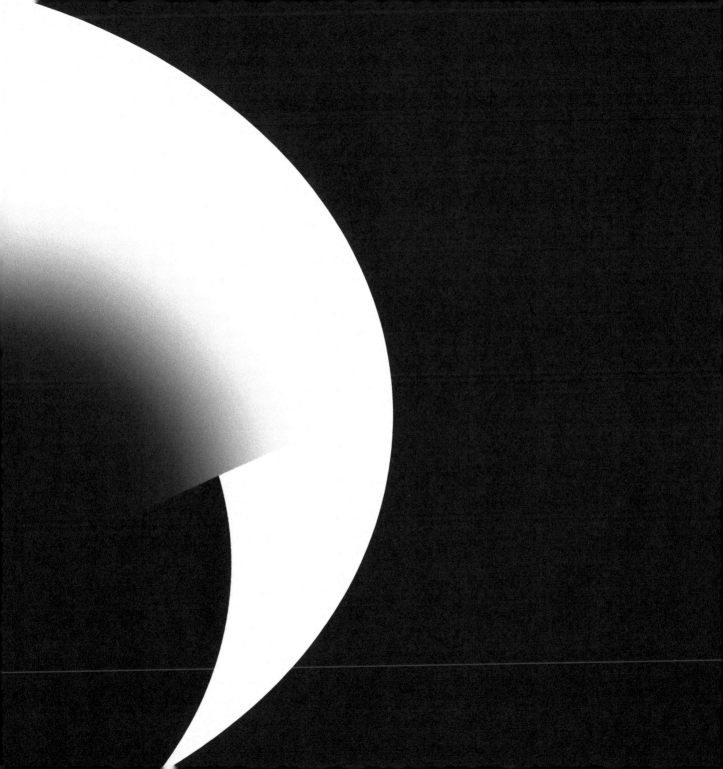

Can you not feel my pain?
I thought we were linked by fire.
I assumed you would always
be in my corner,
especially in crisis.
I feel more alone
than before I knew you.
More betrayed
that you,
my twin,
would abandon me.
Numbness is my only friend,
like a cold blanket
covering my face in darkness.
There is no more fire.

Can I ever explain to you
how grateful I am?
To know myself better
because you were my man.

You expanded my mind
always holding my gaze.
Showing me loyalty's
never-ending, not a phase.

Letting me be my highest self,
I saw myself through your eyes.
Though not always easy,
It shattered my programmed lies.

Dance in the self, honey.
Leave your safety nest.
Go on a quest, venture West.

Dance in the flow, honey.
Don't be so obsessed
with what comes next.

Dance in the Oneness, honey.
Do your best.
Don't forget to rest.

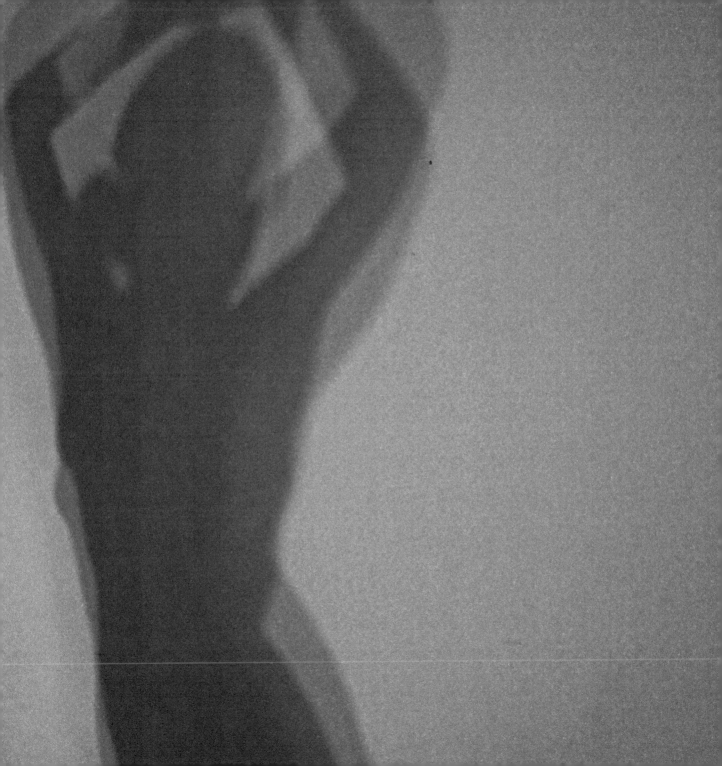

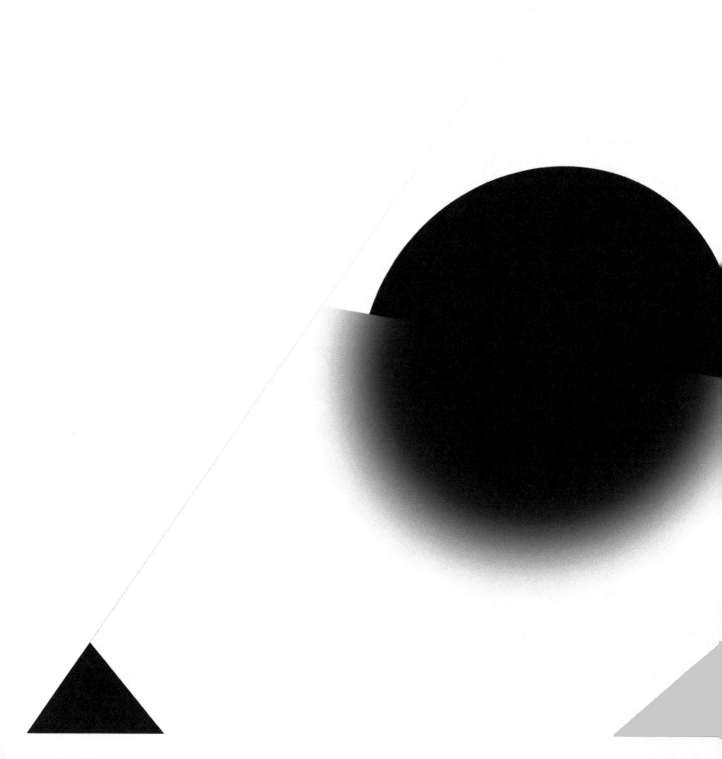

Long lost home,

Aligning me to my purpose.

Going deep within,

Unknown pieces start to surface.

Neural pathways changing,

A new way of being emerges.

Blossoming stillness and trust,

Each shade of me converges.

Although disaster led me here,

Creativity flooded through.

Happily, i leaned in, then my spirit flew.

The crow sweeps down,

reminding me.

I hear your cry.

Do you hear mine?

You stir my soul,

you spark my fire.

Your hand in mine,

is my only desire.

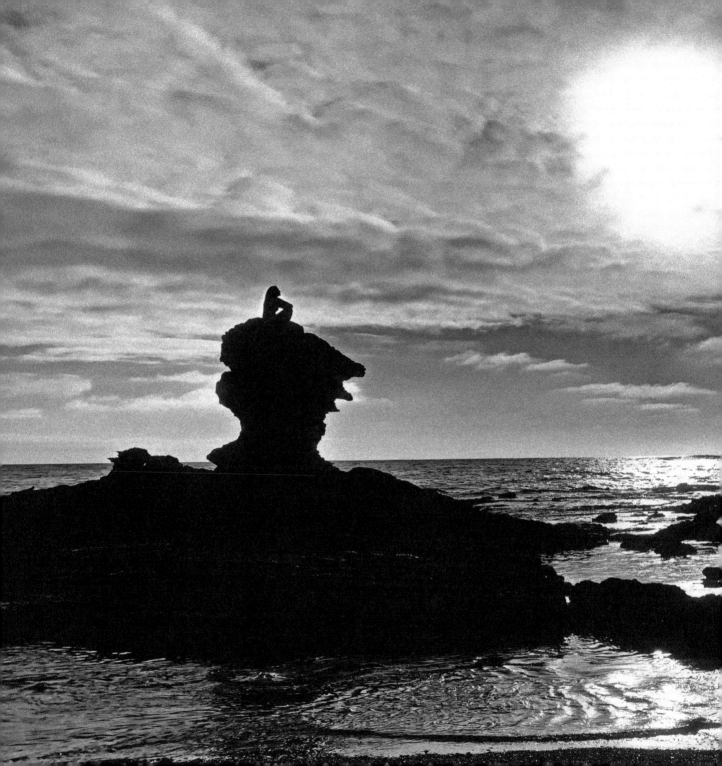

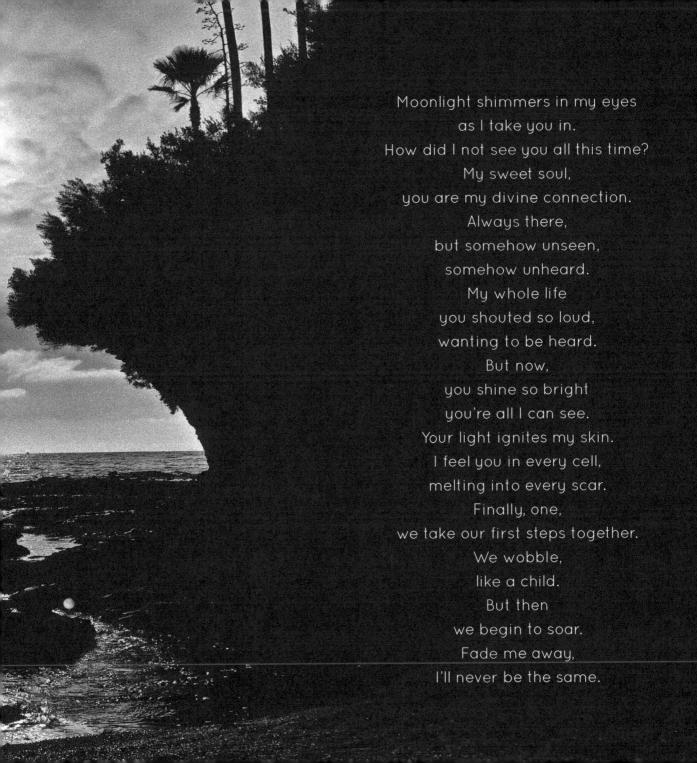

Moonlight shimmers in my eyes
as I take you in.
How did I not see you all this time?
My sweet soul,
you are my divine connection.
Always there,
but somehow unseen,
somehow unheard.
My whole life
you shouted so loud,
wanting to be heard.
But now,
you shine so bright
you're all I can see.
Your light ignites my skin.
I feel you in every cell,
melting into every scar.
Finally, one,
we take our first steps together.
We wobble,
like a child.
But then
we begin to soar.
Fade me away,
I'll never be the same.

Good grief, how many years you consumed my mind.

Radioactive, almost:

Ecstasy and misery.

Grateful for one of my

Soulmates.

Altering my life for the better,

But never my forever.

One more thing: thank you for breaking me. it created me.

Somehow in you
I found myself.
Now,
without you,
I've misplaced her again.

With each experience

I become

more and more

myself.

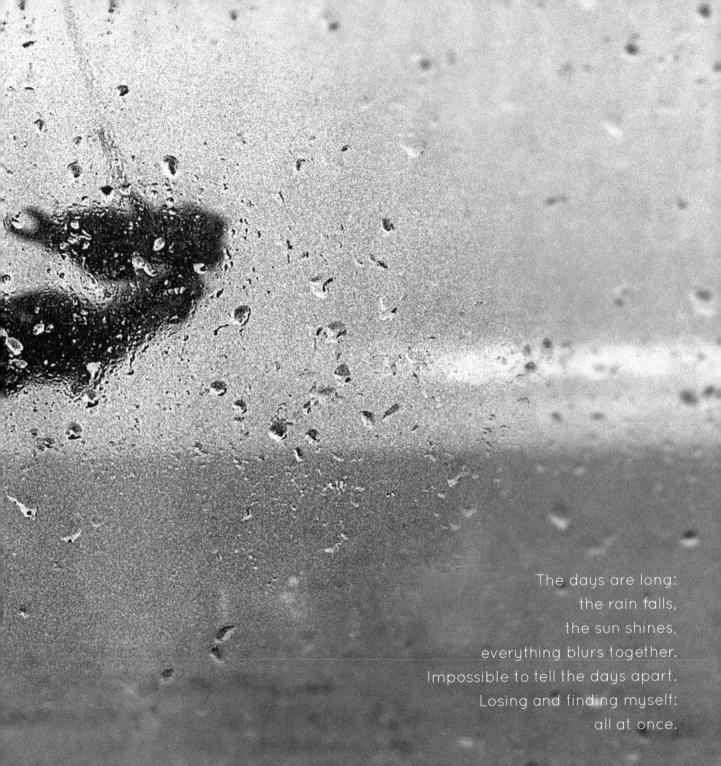

The days are long:
the rain falls,
the sun shines,
everything blurs together.
Impossible to tell the days apart.
Losing and finding myself:
all at once.

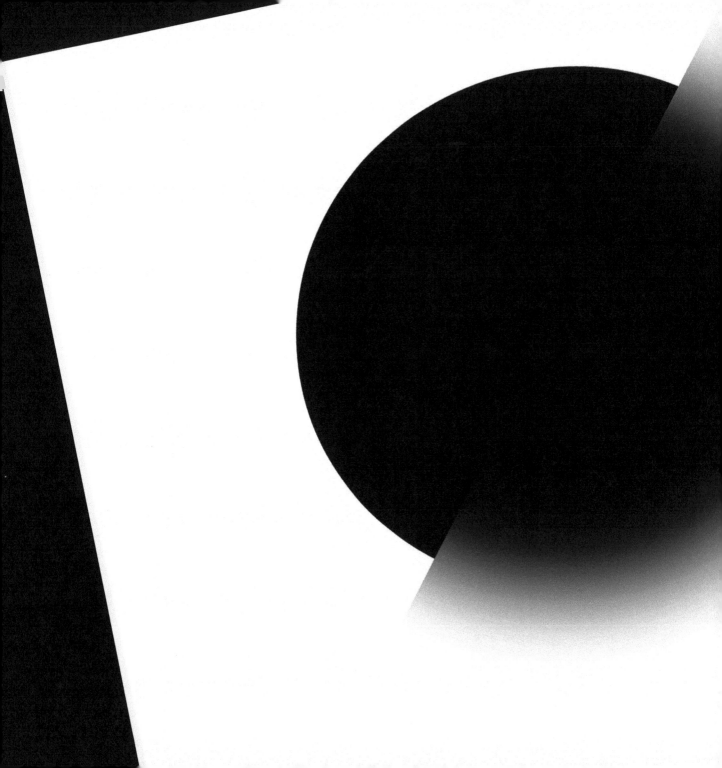

My dear pachamama

Oh, how reverent i am.

There is no end to your mastery,

Huge mountains to a lamb.

Every day you hold us,

Rarely asking us for much.

Never denying us sunlight,

Always blessing us with your touch.

That's what makes you the divine mother,

Unconditional love for us all.

Rise up in your name

Each one of us must. i promise we hear your call.

I thought yours was a word I could

count on.

Someone to

rely on.

A firm foundation to

stand on.

Someone in my corner to

lean on.

But it appears all you want to do is

move on.

The learning

never ends.

The growing

never stops.

The joy

never ceases.

I am so full of bliss.
I could float away.
I attach a string to my wrist.
I'll remember this day.

I am not ready to leave.
I anchor my body here.
I know my work is not done.
I am devoid of fear.

I know my purpose.
I am human and soul.
I help others see their truth.
I have only that goal.

I beseech you to look within.
I have faith in you, darling.
I know you'll get there.
I believe in you, starling.

My first show:
It only took three years to write
(She said sarcastically).
Some years more
Committed than others.
Obsessed i became,
Mostly once artem ignited the spark.
Mother's money helped materialize my dreams.
United, the cast believed in my baby.
Now, i realized, this project was special.
Imagining its success
Constantly and confidently.
Affirmations daily, but
Timing is everything
In this business.
One day, it will affect the world.
No doubt in my mind.

The thing I desire most isn't
money or fame.
It's the only thing I cannot claim.
Something only you can give.
It's tender, it's warm,
a gesture only you can form.
It's the smallest of treasures,
it's your hug, your squeeze.
That's what would mean
the world to me.

I wish I could have known back then,
it wasn't that you didn't love me.

You gave me all you were capable of,
which inadvertently shattered me.

But now I see it wasn't you at all,
the wound was already inside of me.

Little T didn't feel loved growing up,
you just woke it up, unfortunately.

I'm so sorry that I blamed you,
it only took a few years to see.

Without you, I wouldn't have healed,
so grateful for the key.

Do you ever stare at fire
and feel the whole world
reflected back to you?
Its beauty is so alluring that
you long to put your hand in.
For a moment, it seems,
the pain would be worth it.
Maybe I'm confusing fire
with love.
Both can flicker
and scorch.
Except love,
has no extinguisher.

Lost little girl growing up,

Among the bright city lights.

Seemingly perfect family.

Vowing one day to make it big.

Every day felt like summer.

Gone is that life,

Along with her father, ashes to ashes.

Swiftly, forced to grow up overnight.

Do you believe the truths you tell

or

are you just bewitched as well?

Although not my

forever,

you will always be

a great love of my life.

Embedded in me

like my blood.

Unseen but

forever

part of me.

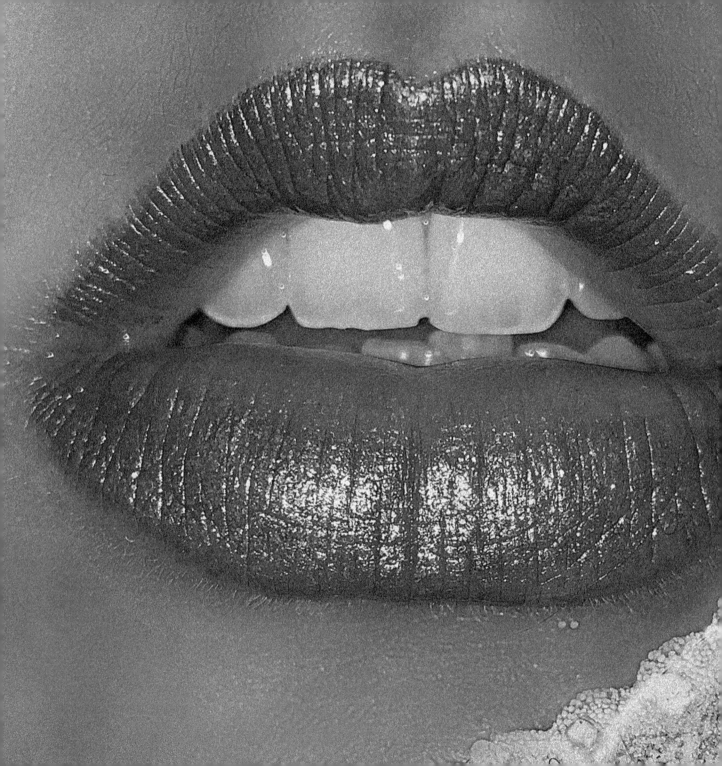

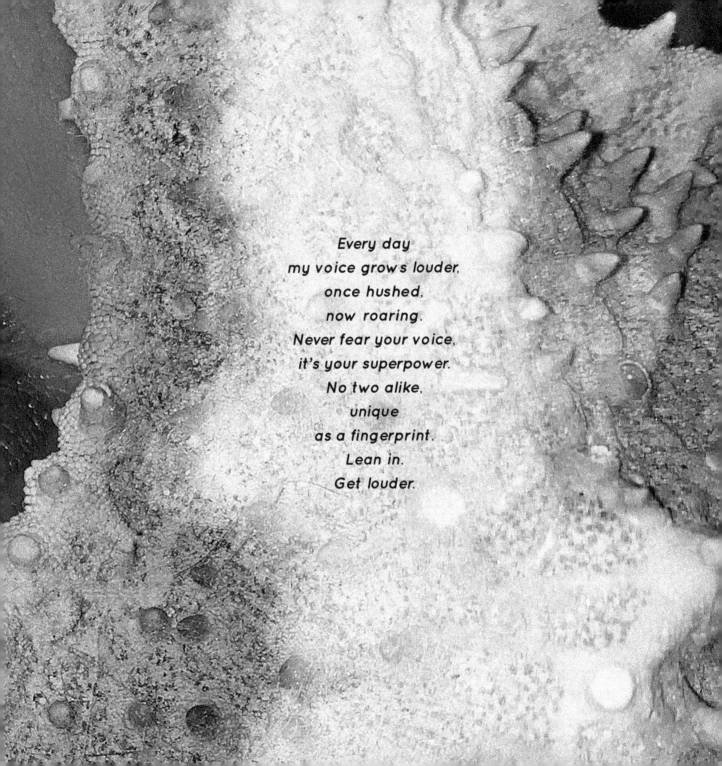

Every day
my voice grows louder,
once hushed,
now roaring.
Never fear your voice,
it's your superpower.
No two alike,
unique
as a fingerprint.
Lean in.
Get louder.

Atypical, to say the least.

Rainbow personality lighting up the world.

Truly talented at anything you touch.

Evading communication,

May be your only vice.

Magic inside and out.

Always bringing out the best in those around you.

Captivating conversation constantly.

How can i ever thank you enough?

No one believed in me so completely, the way you did.

Even your stubborness proves

Valuable for my growth.

I look down and see
a crow pecking at a mirror.
Do you hate yourself that much?
Do you not see what I see?
You have so much light inside you.
Shift it in,
feel its warmth.
You don't have to save everyone
while neglecting yourself.
Love yourself
the way you love me,
unconditionally.
Here comes the second crow
to help her friend.
I'll always be here
to lift you up.
Trust me,
life is so much better
in the sky.

It's interesting,

one day you wake up and realize

you've gotten damn near everything

you ever wanted.

Realization of the century.

It's in this moment,

you step into your power.

Knowing all thought is creative.

Intention combined

with belief and emotion:

anything is possible.

Deep into the jungle I went
to repair my soul,
hoping Mother Aya could fix me.
She didn't,
because I was never broken.
Instead she reminded me who
I am.
The real me emerged
as my body purged.
She showed me death is an illusion,
not a forgone conclusion.
We are all one.
She made me see
it was my own love
I'd been longing for.
My hands became cobras
dancing to the shaman's song.
I was shown I was a healer
in a time long gone.
She whispered to me
the secrets of the universe.
Ego Death.
Rebirth.
Rain poured as I shed my skin.
I woke up light as a feather
face adorned with a grin.

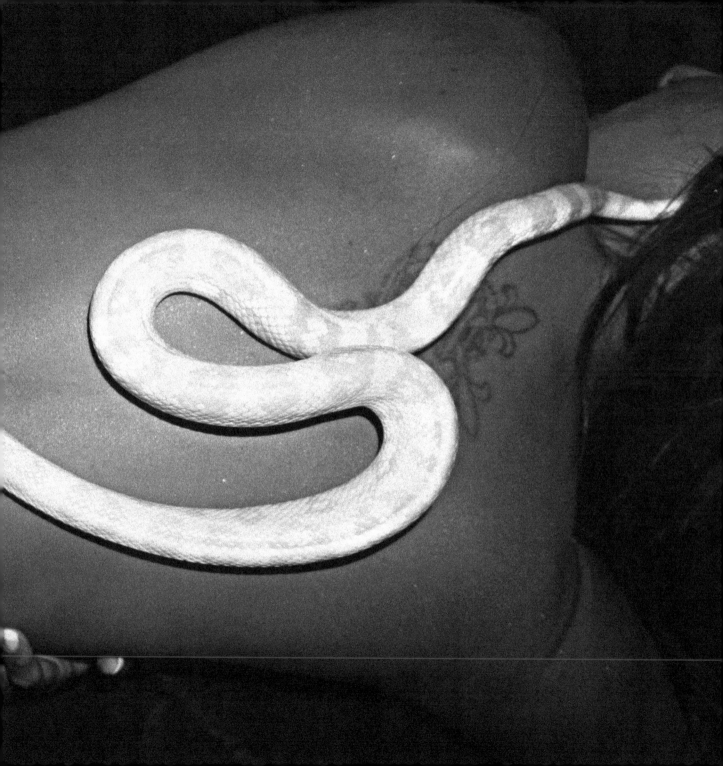

My first love,

Intense and impactful.

Kaleidoscope rainbow of blissful memories.

Effortless connection and loyalty.

Realized how lucky i was to have my first be so true.

All we wanted was a

Simple life together.

Misfortune drove us apart,

Unseen ripple effect of my father's death.

Subconsciously, i pushed you away.

Oh, young love,

Never lasting, never forgotten.

Am I a coward

afraid of the darkness within?

Or courageous

for my willingness

to walk through fear?

What winds your spring?

Is it a lover?

A dream?

Perhaps something unseen?

What brings you hope?

A new job?

Delicious food?

What best enhances your mood?

For me, it's the sunrise.

The promise of a new day.

The past and the future

slowly fade away.

Looking out at the ocean

brings presence, no lack.

Overwhelming sense,

someone has my back.

Why do I watch
so much mindless TV?
Is it so I'll feel
like someone's here with me?
A Band-Aid for loneliness
that's rotting our brains.
Infinite channels,
each numbing the pain.
Quite ironic,
since I work in TV.
I wonder what that says
about me.

Little girl all grown up

Open like a book.

Ready for storybook love,

After a life of being shook.

Irresistible is her charm,

Never putting herself first.

Every drop of her is sweetness,

Face framed with a red burst.

Imagining a life without her,

Opens up my eyes.

Radiance shines from her.

Echo whispers 'she is wise.'

Tension lingers
between a lie and a truth.
Something you don't see in your youth.

Black and white
everything seems,
made up of nightmares or dreams.

The truth is gray
and must be confronted.
Then your real life can be constructed.

Be brave
drop resistance,
in tension lies assistance.

Hundreds of secrets

lie in each cave.

Day and night

people use you to misbehave.

I'm like a cave,

filled with secrets to the brim.

I won't admit it

but most of them are about him.

I feel like I'm on a roller coaster,
up and down,
up and down.
Energetic bliss,
followed by overwhelming exhaustion.
Is it a fairytale
to dream of a constant state of being?
Perhaps it's the
ups and downs
that show us
we're alive.
For even nature
in all her glory
does not know stability.
And she is
most alive of all.

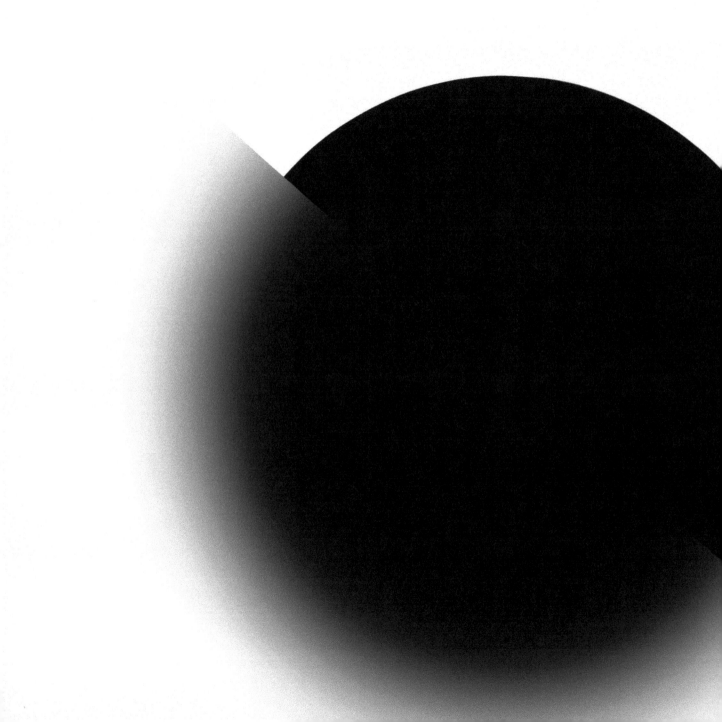

Authenticity is your superpower.

No one loves animals the way you do.

Gentle is your nature,

Even when it hurts you.

Lovingly always supporting me.

After my dad left, you became my family.

A gift i can never repay.

Big-hearted towards the earth,

Supporting her in every way.

How many times have

I called you crying. never once turning me away.

Elegant as a vogue ad, you're a

Radiant runaway.

Sometimes
I am so reactive it hurts.
It's like I am watching someone else
be mean to those I love.
I could never be so harsh
and say those things.
Could I?
But I did.
How is it possible
to not recognize yourself
sometimes?
What if one day I wake up
and all the good parts have vanished?
Only the cruel remaining.
Two voices at my shoulders.
Am I the angel,
or the devil?

Creativity flows through me
like a river from the lake.
She chooses when to inspire me.
I used to demand her presence,
now she commands mine.
We work
hand in hand,
nurturing each other.
Together,
with our words,
we will change the world.

How incredible is the sun?
How blessed are we for her light?
Bright sunshine after a night of rain,
washing yesterday away.
The sun reminds us of a promise of
a new day,
shining
no matter what.
She doesn't judge,
never holding back her light.
Confident.
Unfailing.
Brilliant.
True.
I choose to be more like the sun.

Drunken nights we had a few.
Every time i think of college, you come into
View.
Only you saw the true grief of my dad.
No matter what we did,
My friend, you
Caring for me, made me less sad.
Childlike we always acted,
Loitering on campus at night
Endlessly distracted.
Lucky i was to have your support.
(Listening to jimmy eat world nightly)
Although our friendship was cut short.
No amount of thank you will ever be enough.
Dev, you got me through that year, i know it was tough.

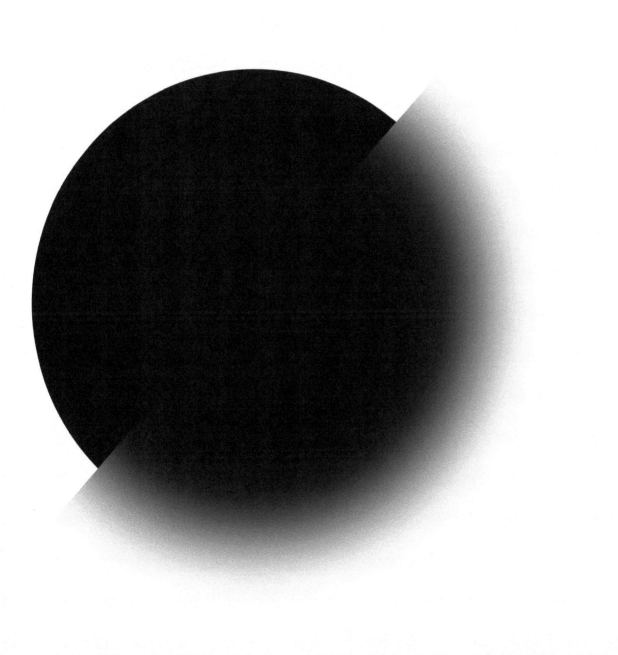

The world is a façade
a cauldron of self-absorption,
just an extravagant distortion.

Is it possible to
to see behind the veil?
Maybe there you'll find the Holy Grail.

It takes courage
to see beyond what's easy.
An action that makes capitalism uneasy.

Beyond the matrix
lies the truth.
Try and crack the code in your youth.

That way you'll have a full life of
not playing the puppet.
Then you will reach the summit.

You must be
yourself.
How else
is your soulmate,
who is searching for you
through time and space,
going to find your soul?
If you're pretending
to be
someone else.

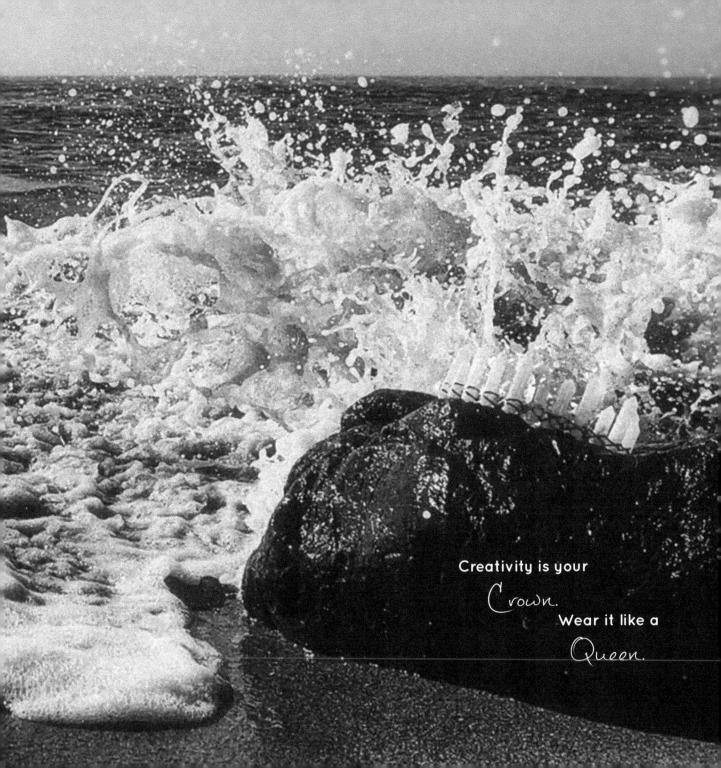

Creativity is your

Crown.

Wear it like a

Queen.

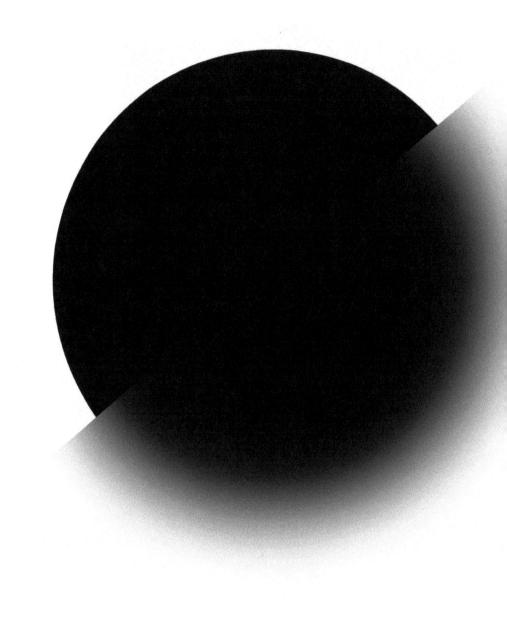

Dear friend,

Wisdom lies in our connection.

Are we simply

Reflecting for

Karmic intersection?

Acceptance opportunities,

Peaceful rendezvous,

Adventurous encounters,

Zero coincidences through and through.

Sometimes I wonder
when I learned how to act.
Was it when I told my friends
in middle school
that my parents were happy?
Was it when I told my dad
I didn't mind
if he missed my play?
Was it when I told my friend
I didn't mind
being left out?
Was it when I told my mom
that I wasn't
afraid of the dark?
Then it hit me,
I've been acting my whole life.

Melt with me
into hedonistic revelry.
I promise you
it's not some new age deviltry.

We are young
and deserve a good time.
I'm sick of society
making that feel like a crime.

Drop your inhibitions
and kiss me in the rain.
I promise you,
it'll help ease the pain.

Life is short
and the days are long.
Haven't you realized yet,
you must write your own song?

I notice myself in the mirror.
I look exactly
how I've always felt inside.
Happy. Gleaming. In love
(with myself this time).
I can feel how proud my dad is.
When he left, I was just a girl.
Now, a woman, I feel his love
more than ever.
I feel it every single time
I pick up my pen.
Sometimes,
I feel like
it's him writing.

Serendipity brought me here.

A place that would shape me.

Now i can see it all happened for a reason.

Destruction of my ego that sprung

Inspiration.

Easy living doesn't make for a good story.

Guidance from my genius

Offered my experience to create a show.

I look for you

in every song.

Pieces everywhere

and nowhere.

Believe me
it's a wonder,
when you finally
meet yourself.

Oh, sweet solitude,
the thing I used to fear
the most
has become my best friend.
The beauty
in the silence
is intoxicating,
like a glass of whiskey.
I continue to drink,
wanting more.
Bottoms up.

Many have a brother
An older one just like me.
Dominant growing up
In him, my dad i see.
Sweetness hidden deep
Only those he treasures see.
Not much for patience
Family especially, meaning me.
I look at him in awe
Observing all he's done.
Realizing he's my best friend.
Empowering as the sun.

I miss your hand holding mine,
strong and secure.
I miss your hug,
engulfing me in warmth.
I miss your belief in me,
making me feel superhuman.
But most of all,
I miss your soul.
The one mine recognized
the moment we met.
The one I've known
a thousand lifetimes.
The mirror of mine.

Give your soul, my love.

Gratitude is filled
with peace.

Forgiveness
with love.

Nature is filled
with support.

Silence
with answers.

Am I the girl I see in the mirror
face blemished,
eyes filled with tears?

Am I the longing I feel inside
to be seen?
The seemingly insatiable void.

Am I the sum of my parts?
The mountain of memories
good and bad?

No.

I am the hushed voice deep inside.
I am the flicker of gold in my eyes.
I am the wild.
I am anything I want to be.
I am more than what can be seen.
I am everything and nothing.
Pure and simply,

I am.

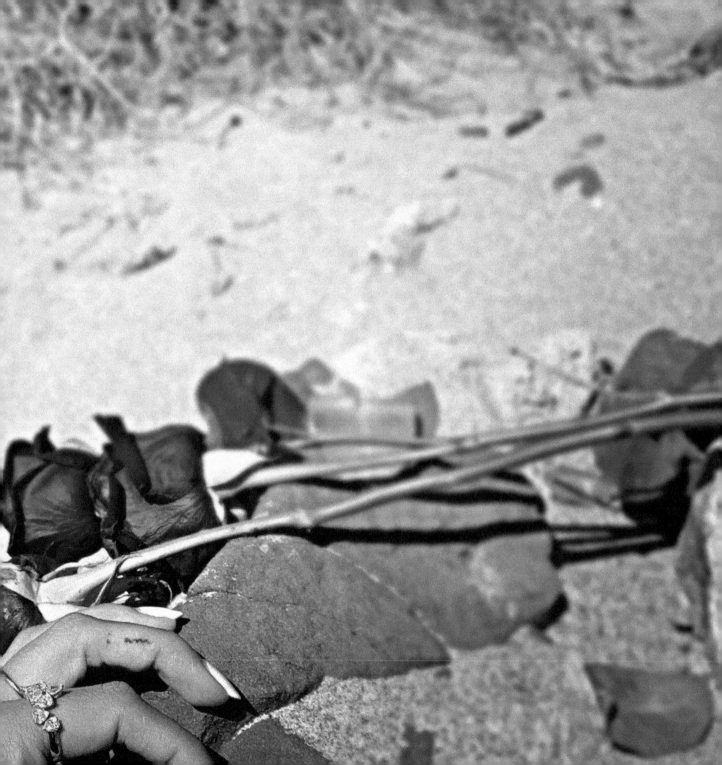

Spectacular serendipity abounding.

Universal flow guiding me.

Radical

Realizations, that i am not in control.

Effortless synchronicities making the impossible easy.

Nirvana in not knowing what comes next.

Divine devotion and complete trust

Electrify the present moment.

Radiant magic guaranteed.

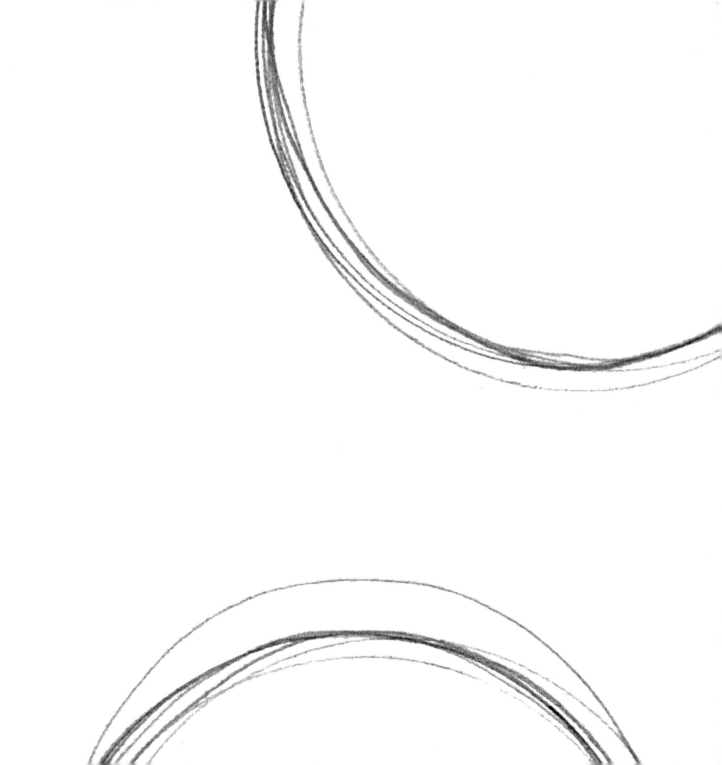

If I don't make it,
am I finally proving to myself
what I feared all along?

If I don't make it,
would that mean
my dad's faith in me was wrong?

If I don't make it,
maybe it means
that I'll never belong.

If I don't make it,
does it make me worthless,
or just gone?

You taught me how to dance.

How to free my soul

that's been bonded for decades.

You taught me how to dance.

How to make love to the universe,

the most giving of lovers.

You taught me how to dance.

How to face my fears.

You freed me.

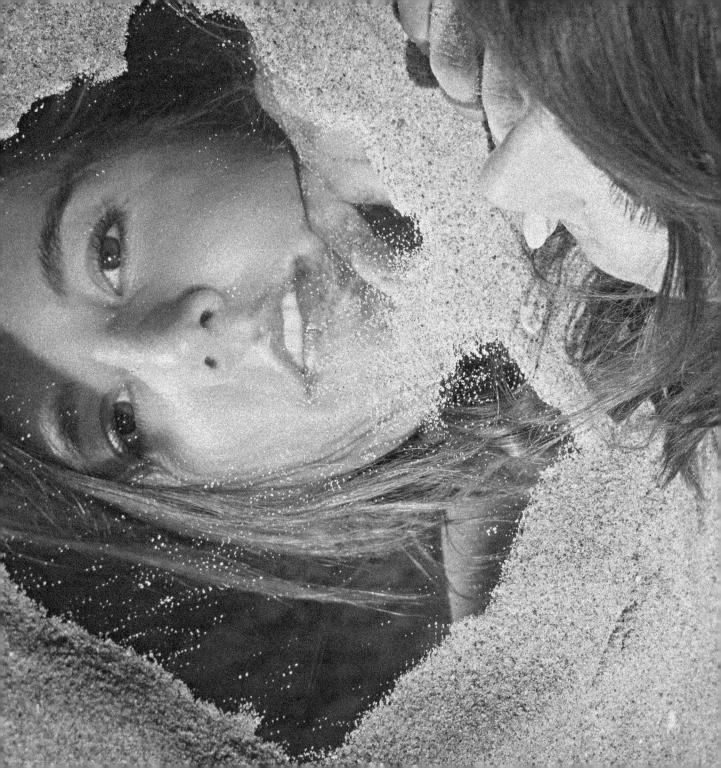

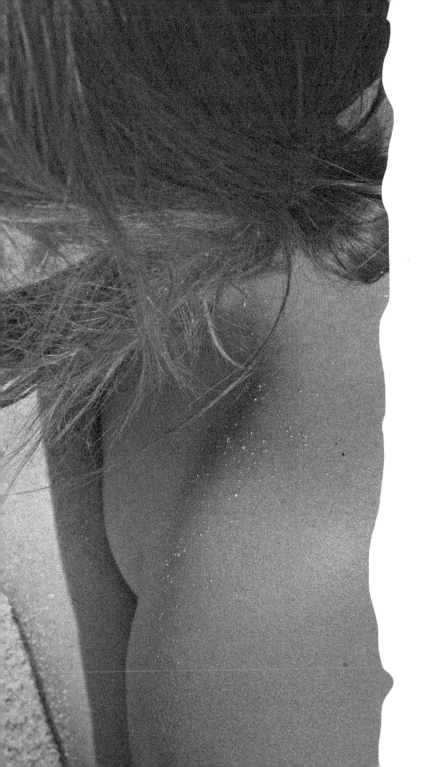

Mirror mirror
on the wall
Who is the truest of them all?
Is it me,
or my reflection?
Am I asking the right question?
If every person is me
and I am them,
why can't we find
the internal gem?
Why this lack
and separation
when everyone is our relation.
The next mirror I see
I'll treasure the reflection,
knowing it's leading me
in the right direction.

Tender big heart,

Always gives too much of herself.

Little does she know how bright her light shines.

Young at heart,

Never passing on an adventure.

Fragile and ferocious.

In the past she played the victim,

Only to find

Real character is born out of the broken pieces.

Endless gratitude for the pain that led her to herself.

Do you know
how hard it was
to feel less loved
because you were so talented?

Do you know what shadows do best?
They're invisible.
They're stepped on.
They're mute.
They're unimportant.
That's how it felt
to be your sister.

I see now
Ii wasn't your choice.
So, I forgive the child
who I once blamed.
But now you're a man
who sometimes acts like that child.
That's harder to forgive.